THE ART OF Laurel Burch™

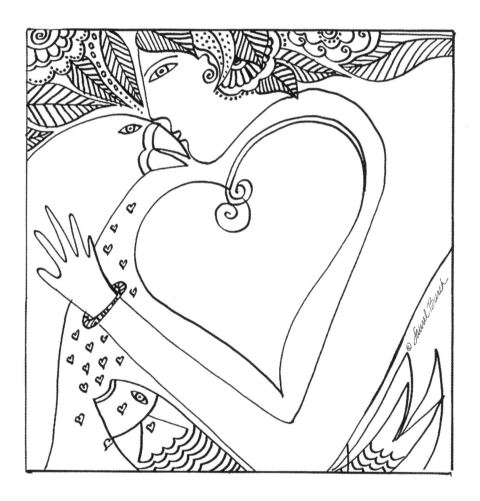

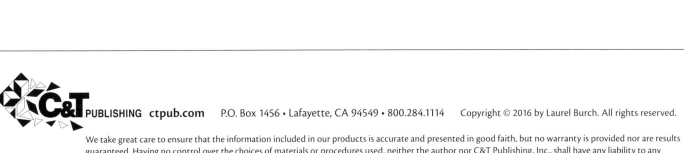

We take great care to ensure that the information included in our products is accurate and presented in good faith, but no warranty is provided nor are results guaranteed. Having no control over the choices of materials or procedures used, neither the author nor C&T Publishing, Inc., shall have any liability to any person or entity with respect to any loss or damage caused directly or indirectly by the information contained in this book.

All rights reserved. No part of this work covered by the copyright hereon may be used in any form or reproduced by any means—graphic, electronic, or mechanical, including photocopying, recording, taping, or information storage and retrieval systems—without written permission from the publisher. The copyrights on individual artworks are retained by the artists as noted in *The Art of Laurel Burch*. These designs may be used to make items for personal use only and may not be used for the purpose of personal profit.

Attention Copy Shops: Pages may be copied for personal use only.

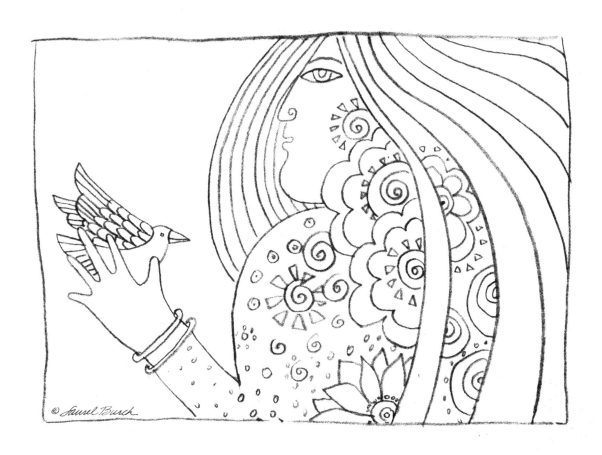

close your eyes
and dream a dream...
and seek the courage
to make it real.

reflect on the past.
envision the future.
embrace today with passion.

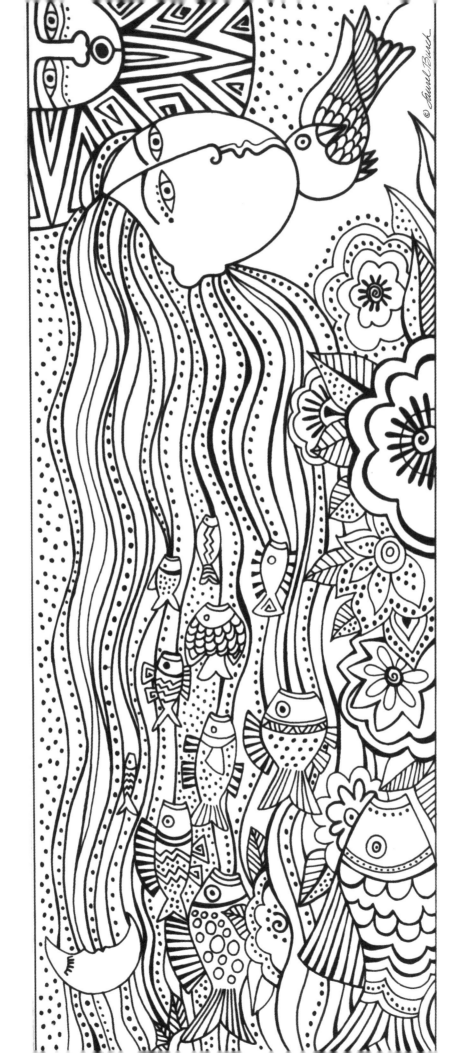

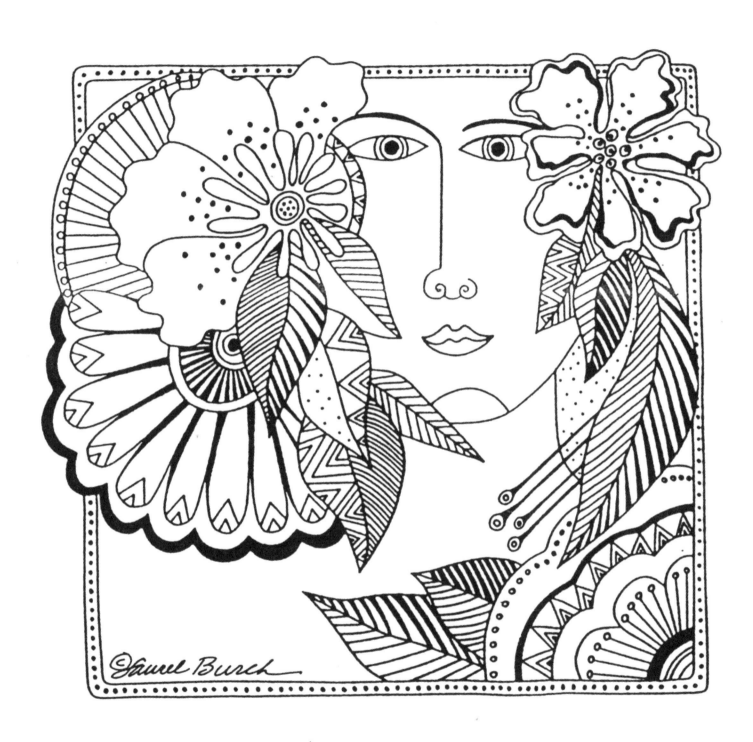

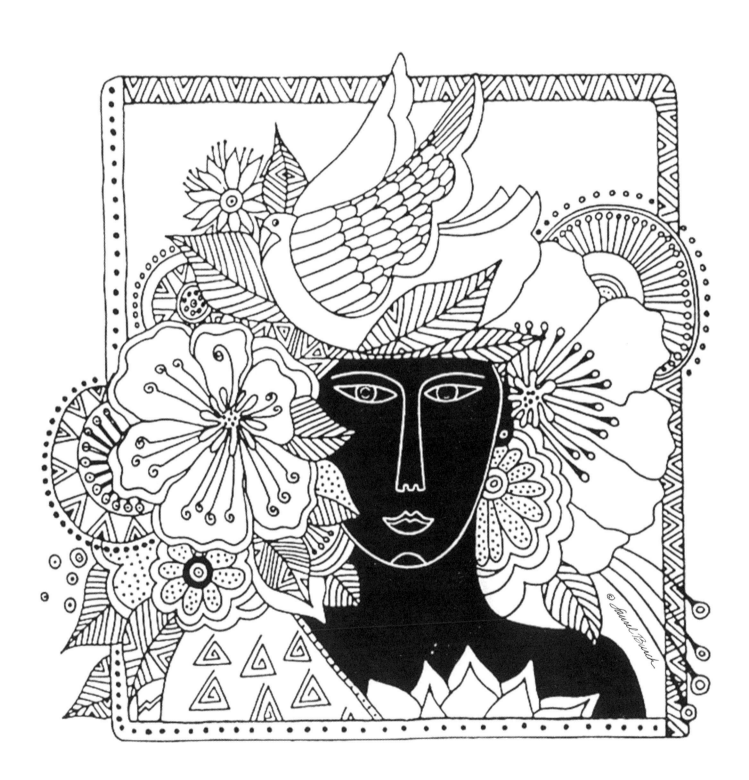

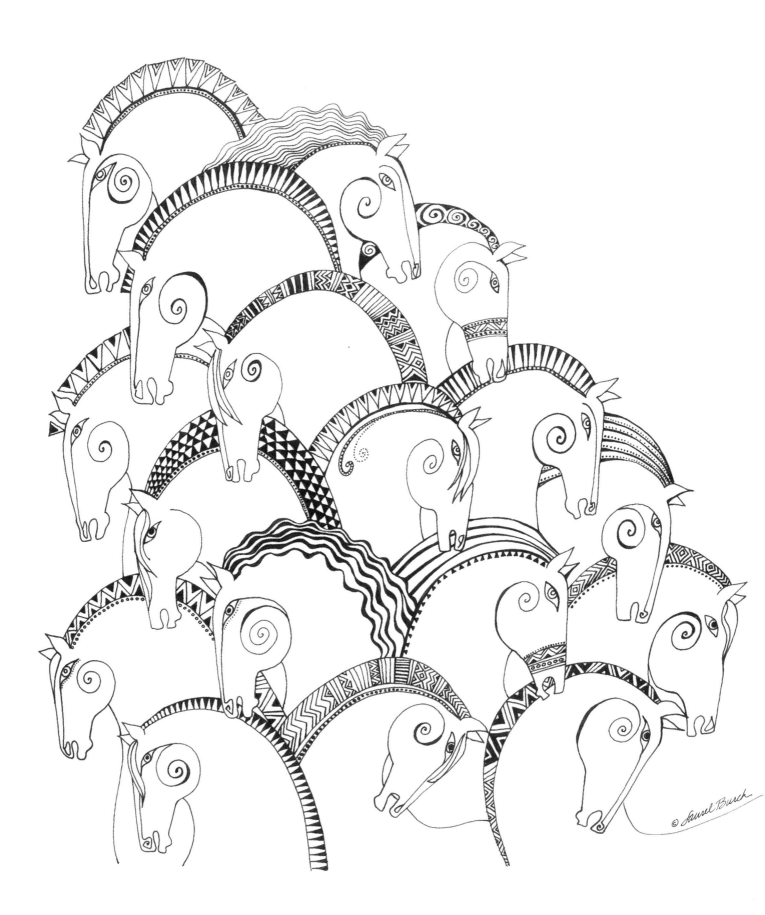

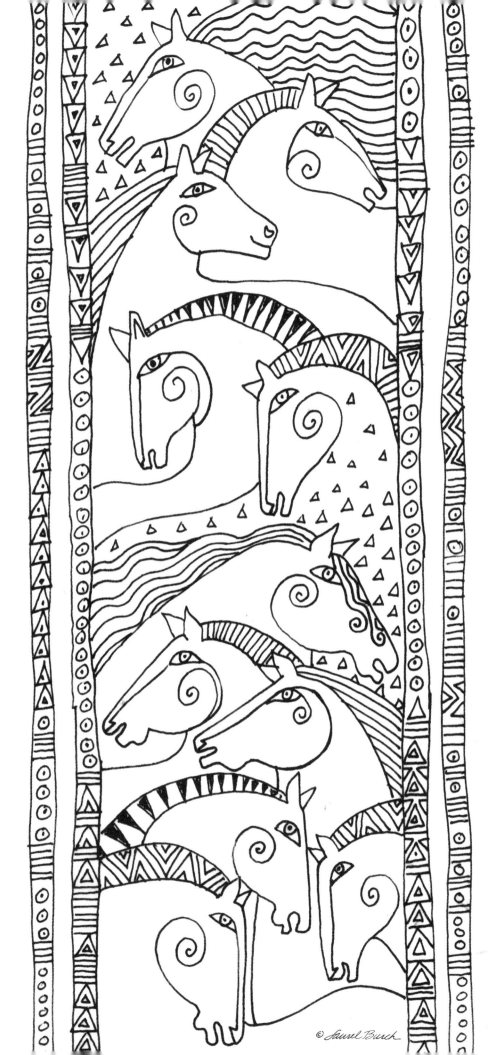

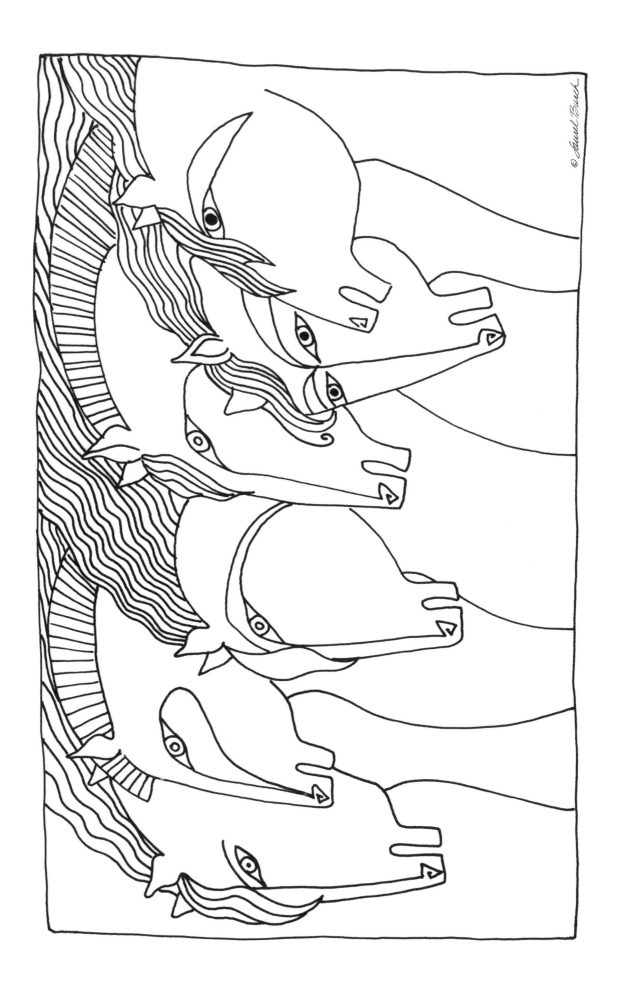

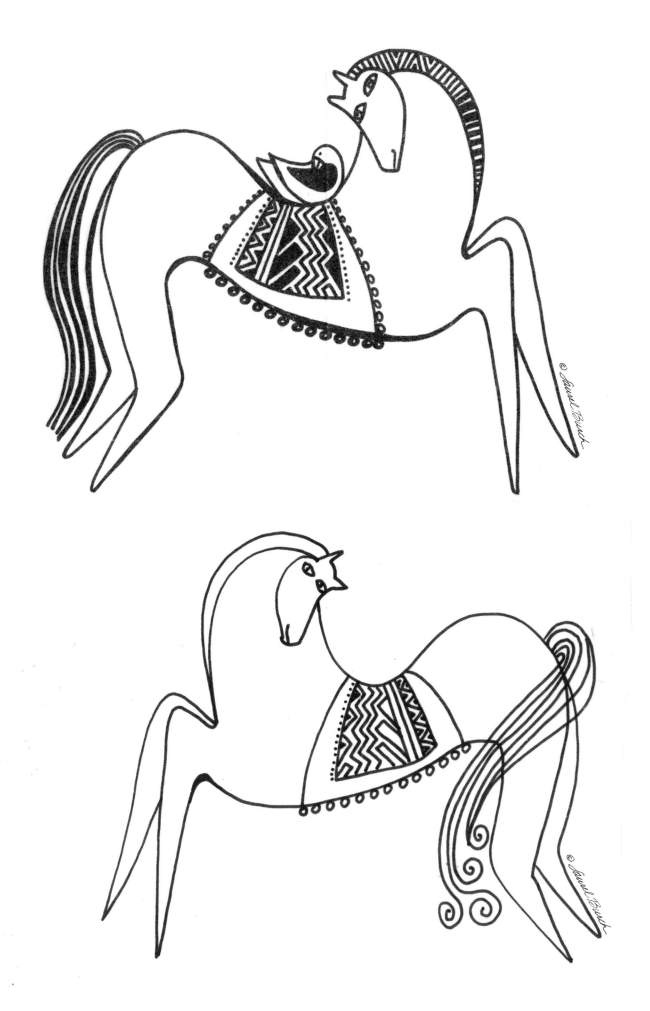

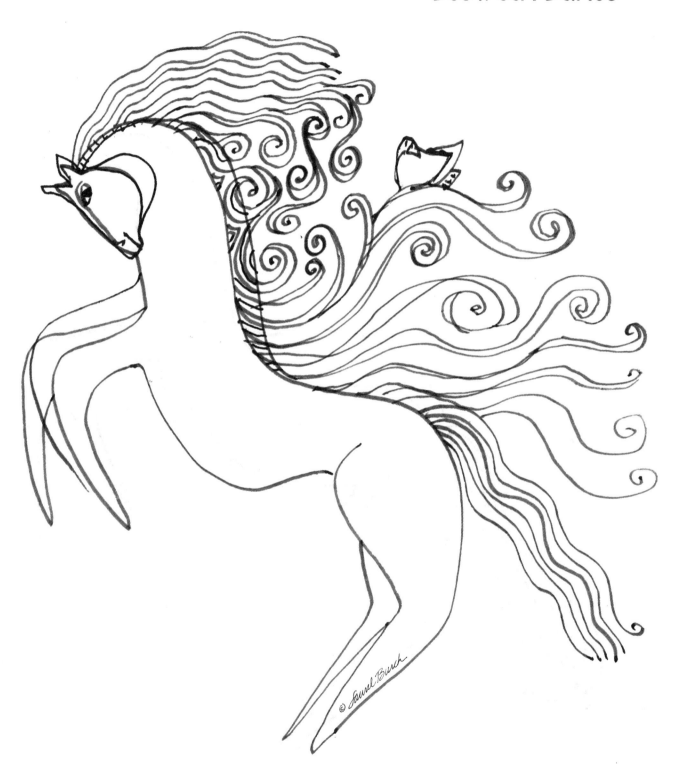

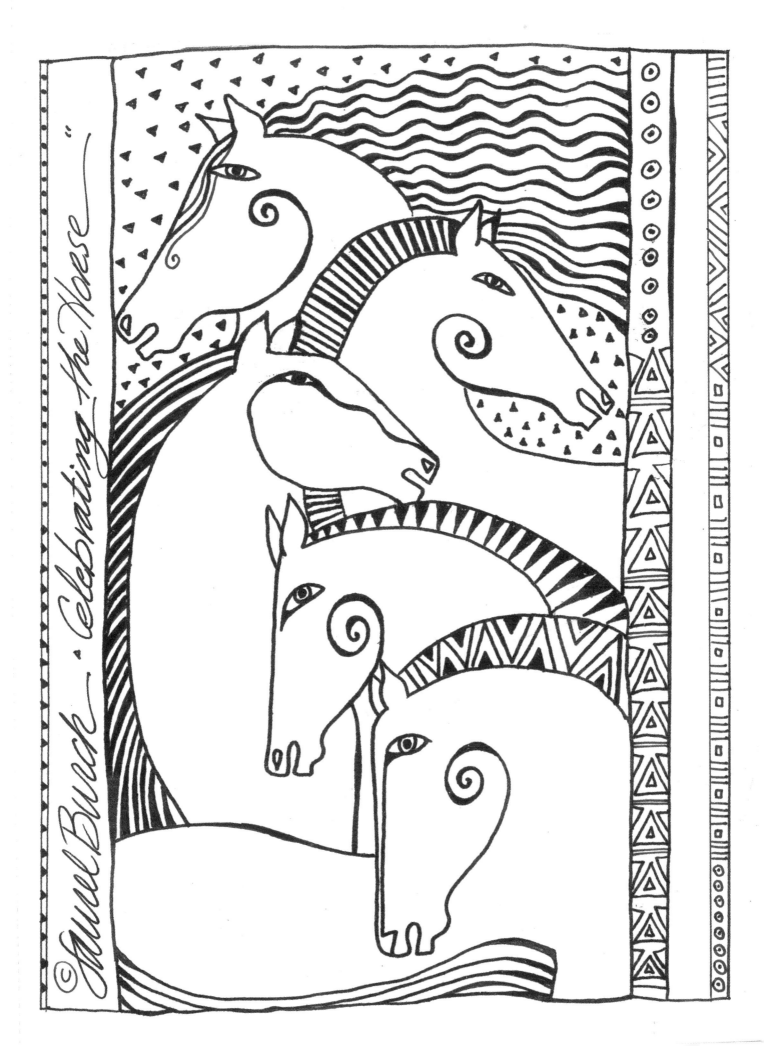

TRUST FAITH PASSION HOPE MAGIC

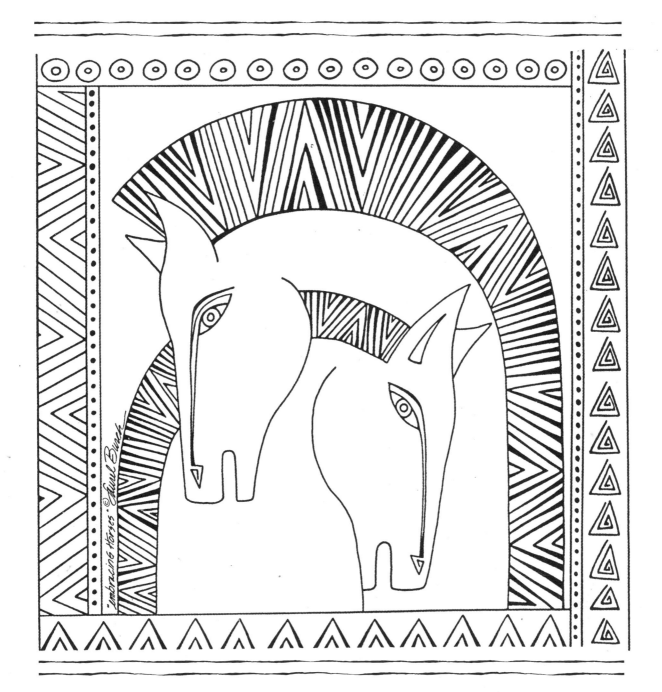

PERSEVERANCE HARMONY BALANCE

there is a very special place in all of us where we can

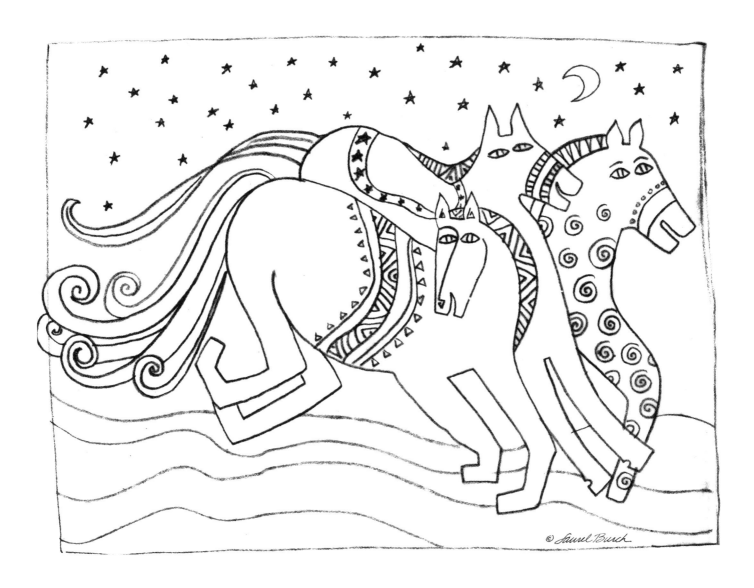

sing and dance and celebrate our own free spirit

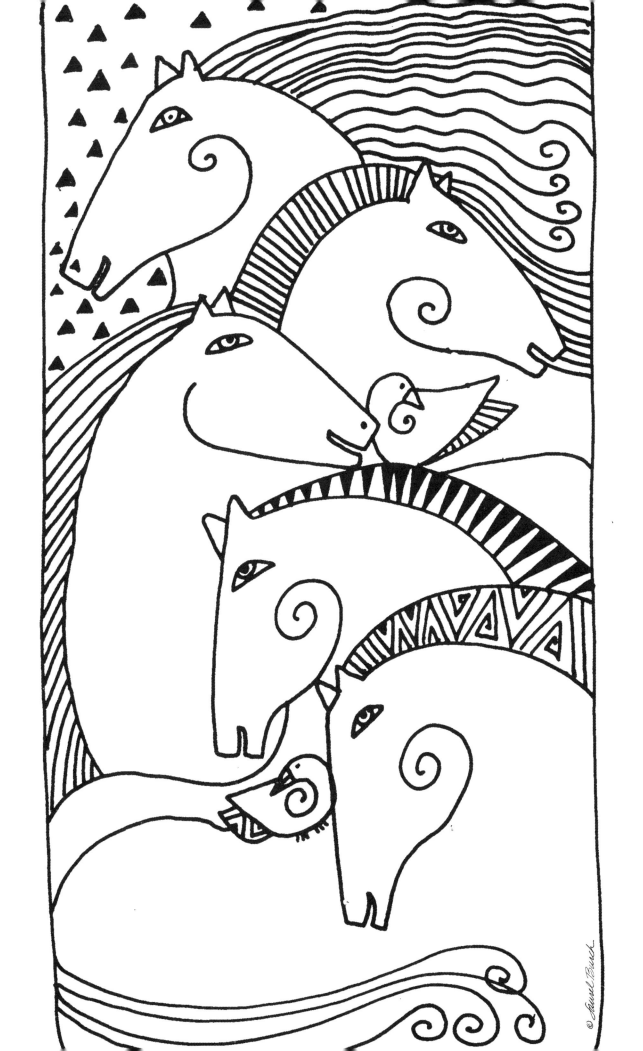

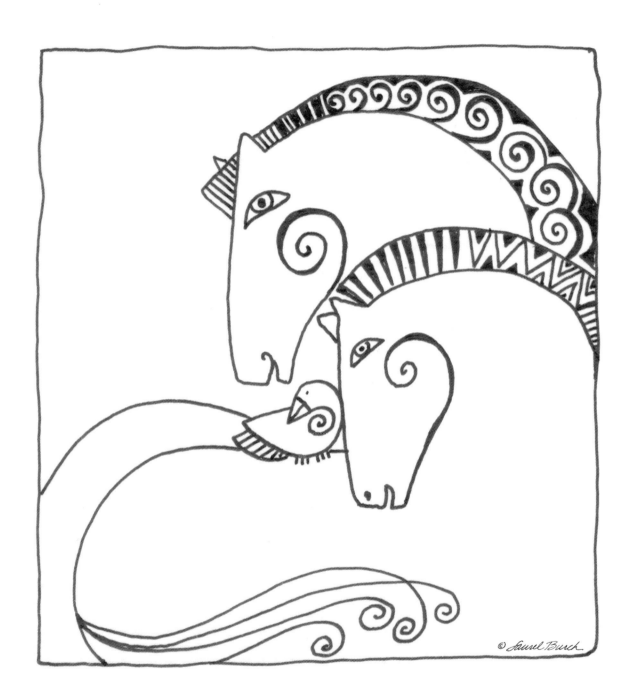

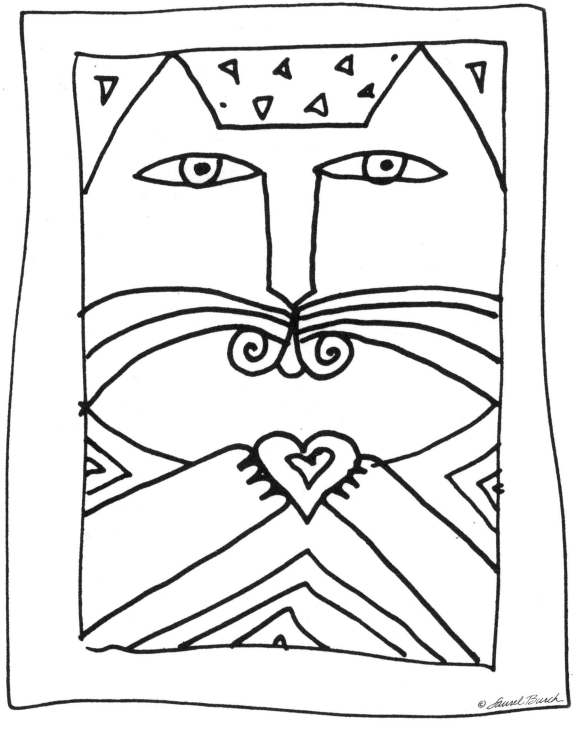

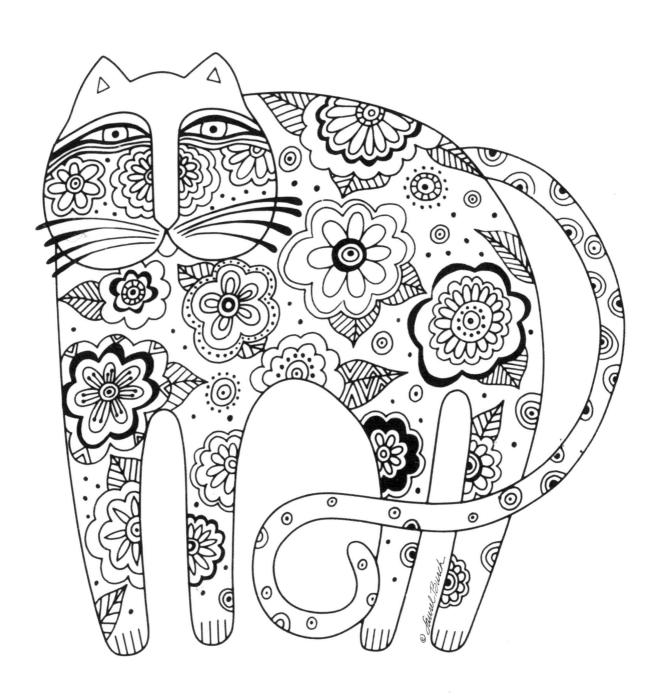

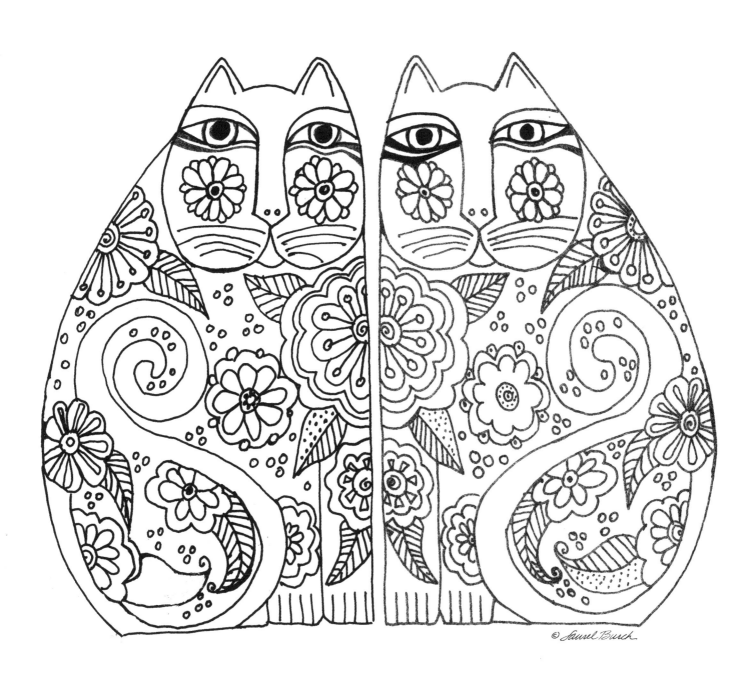

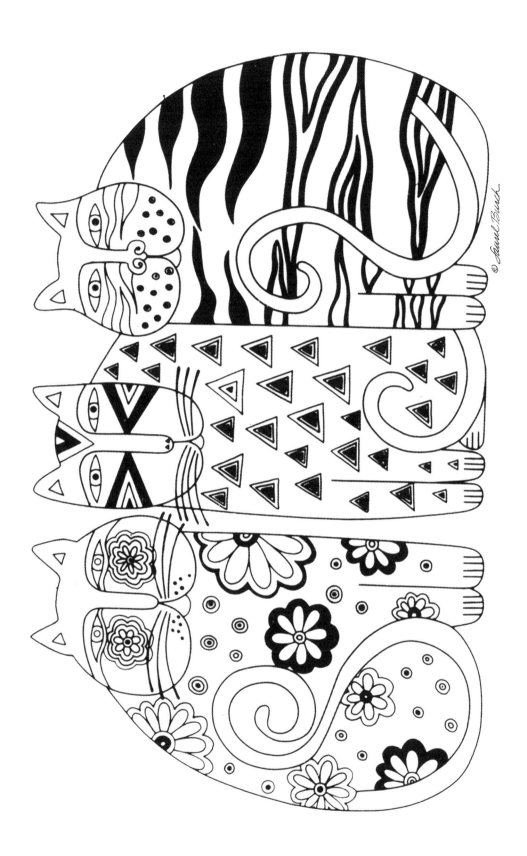

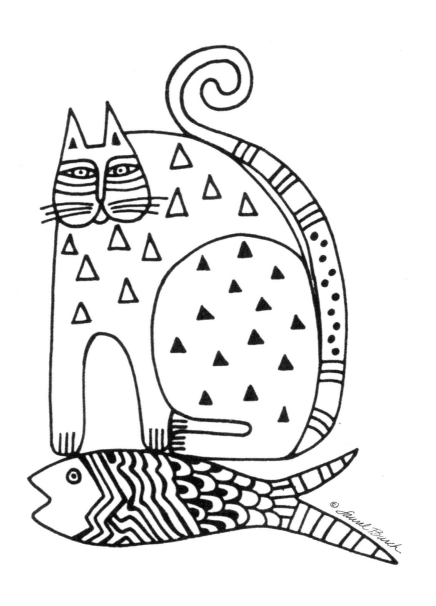

WELL BEING

INNER BEAUTY

RENEWED SPIRIT

WISDOM

BALANCE

HEALTH

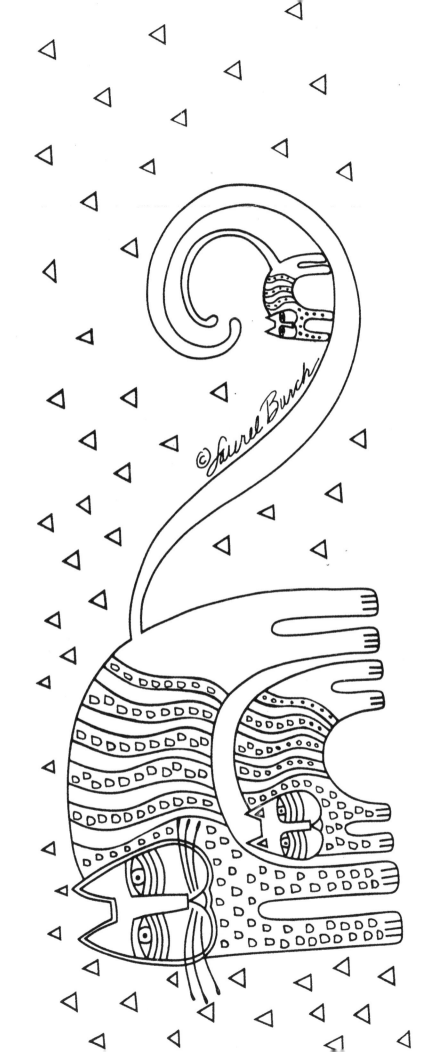

The Art of Laurel Burch Copyright ©2016 by Laurel Burch. All rights reserved. ctpub.com

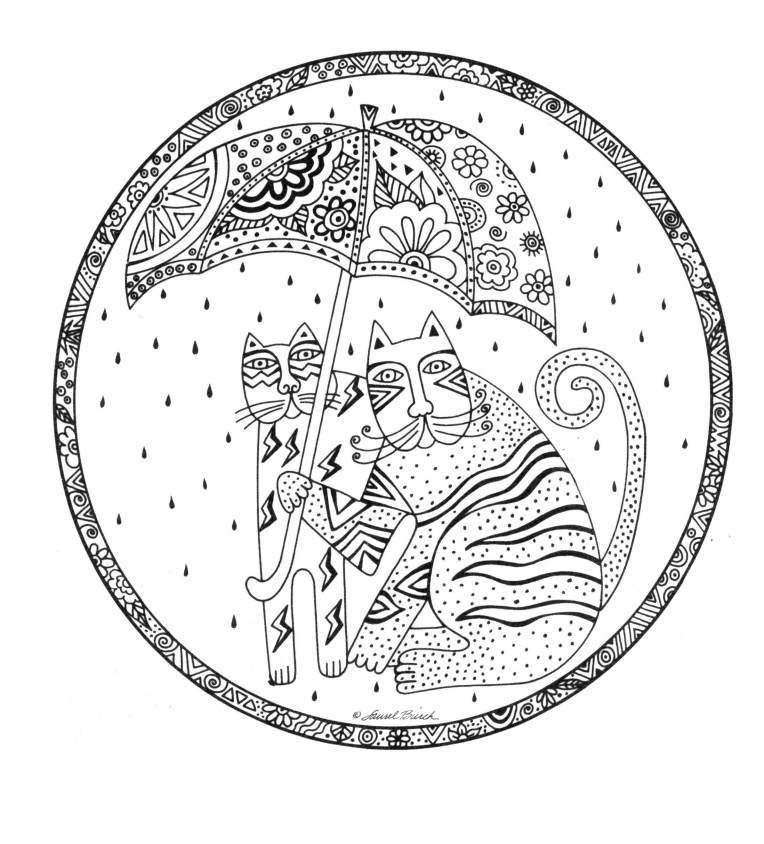

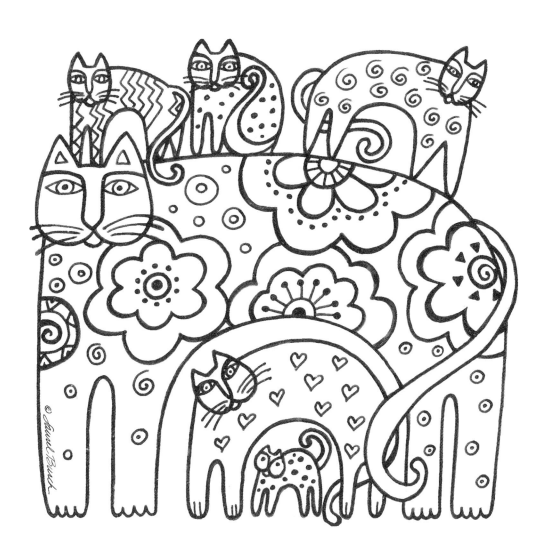

We share similar passions and dreams about the importance of magic in our lives, and the kinship between all living things.

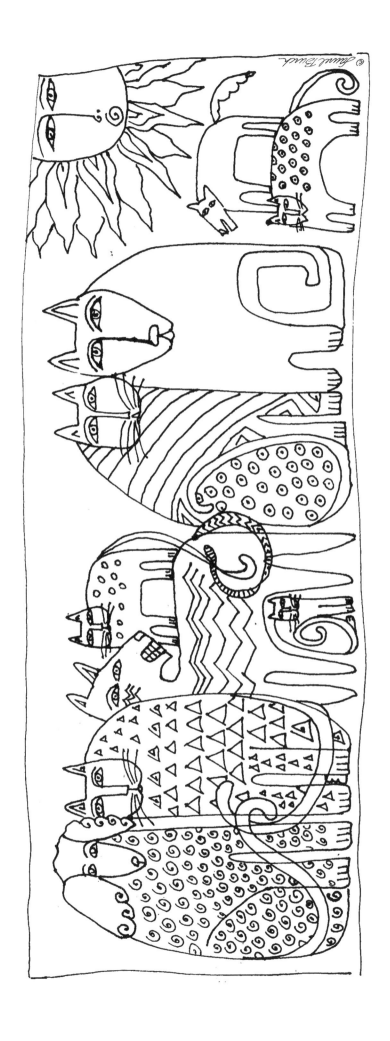

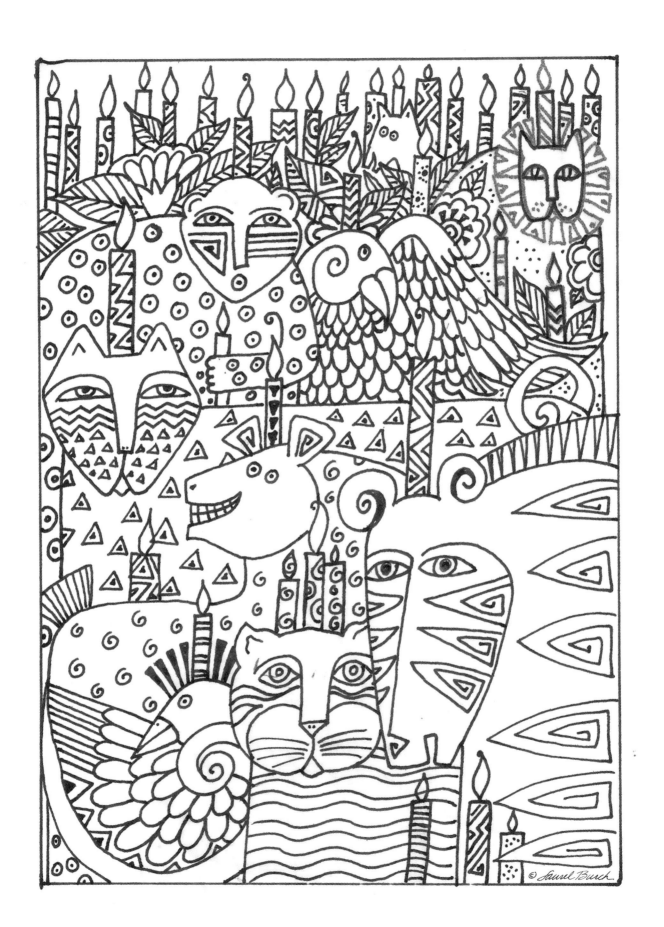

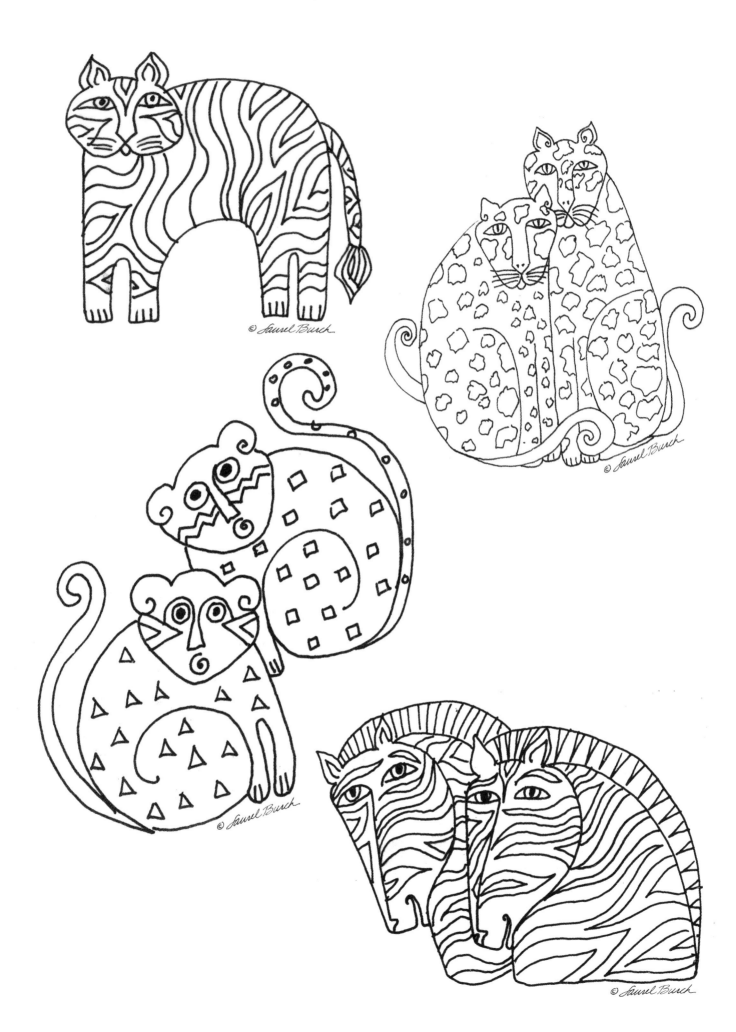

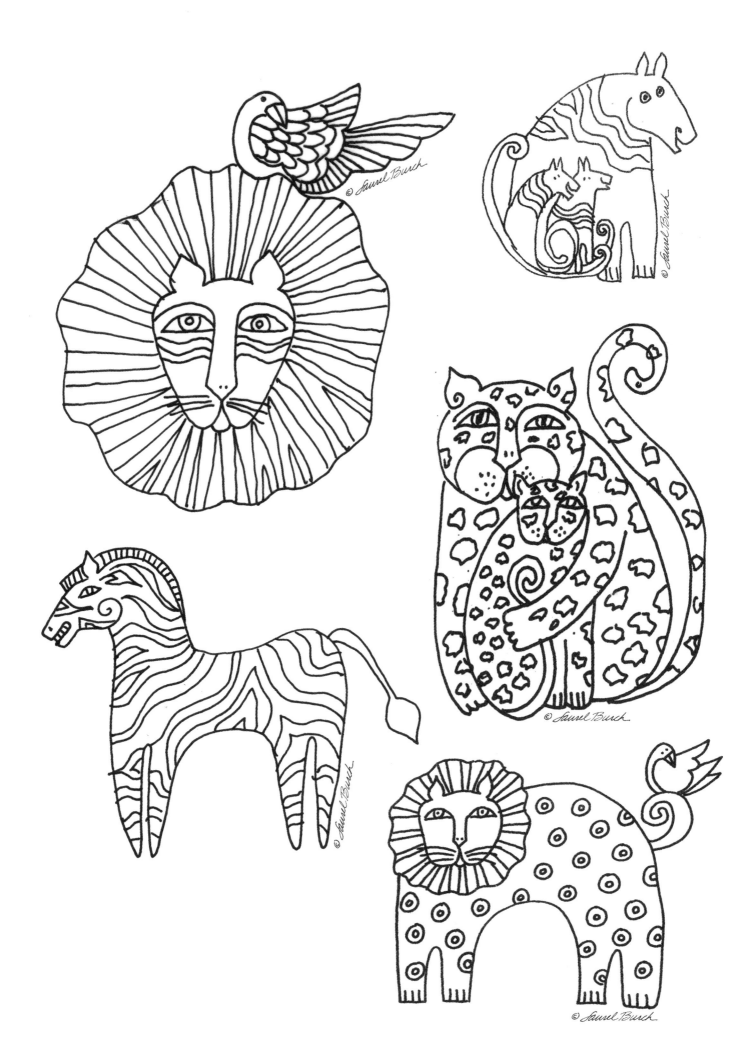

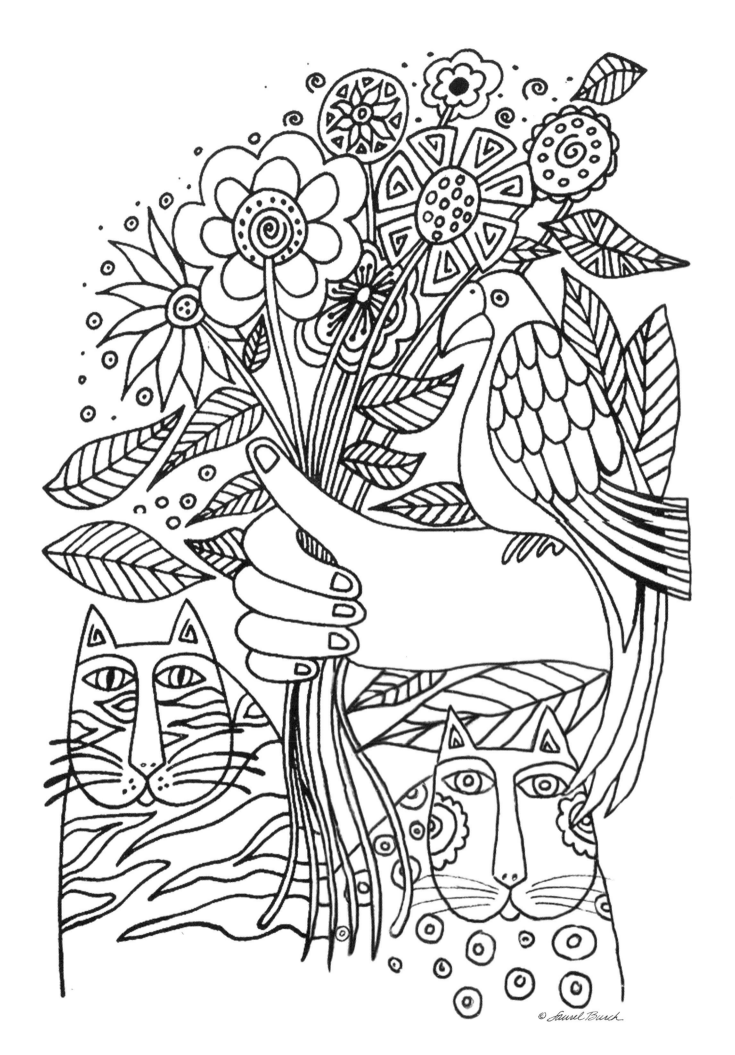

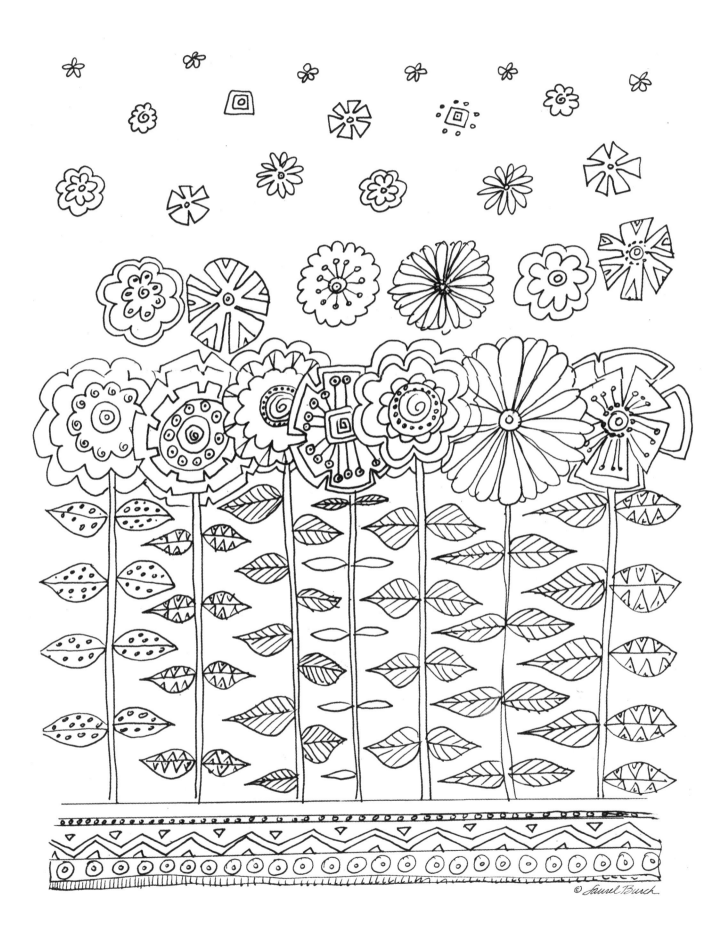

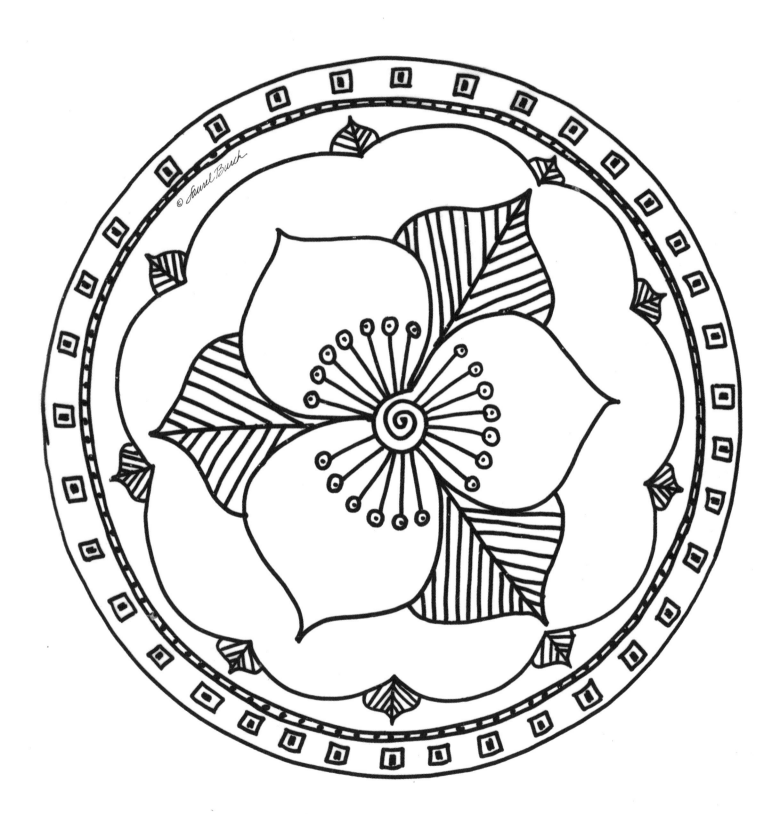

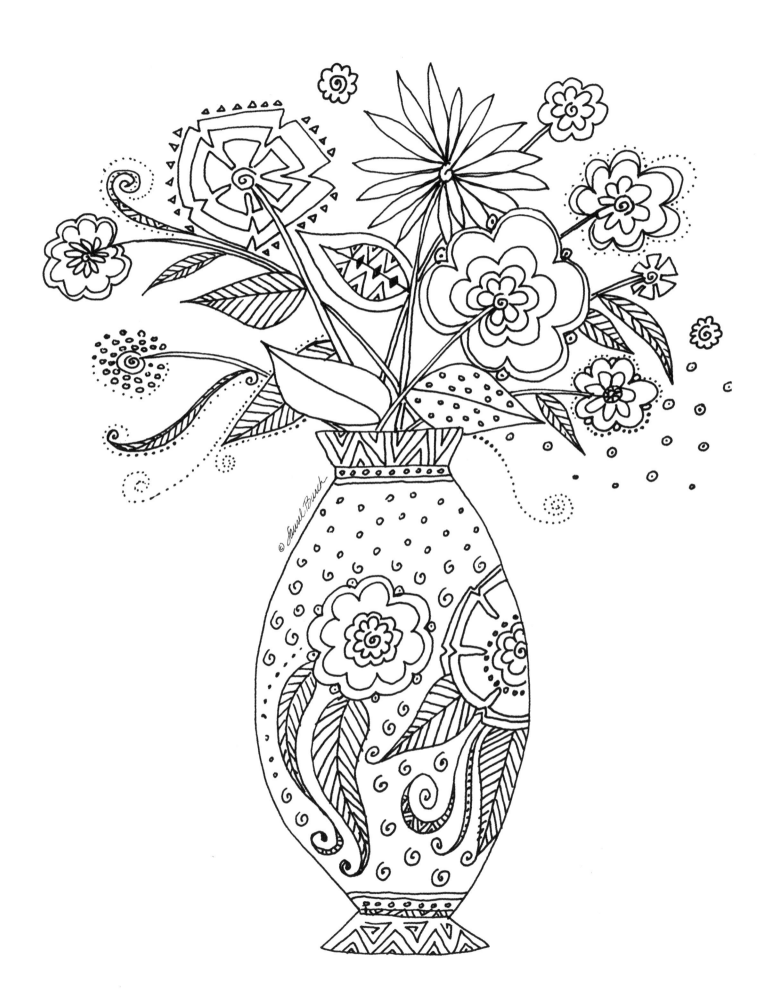

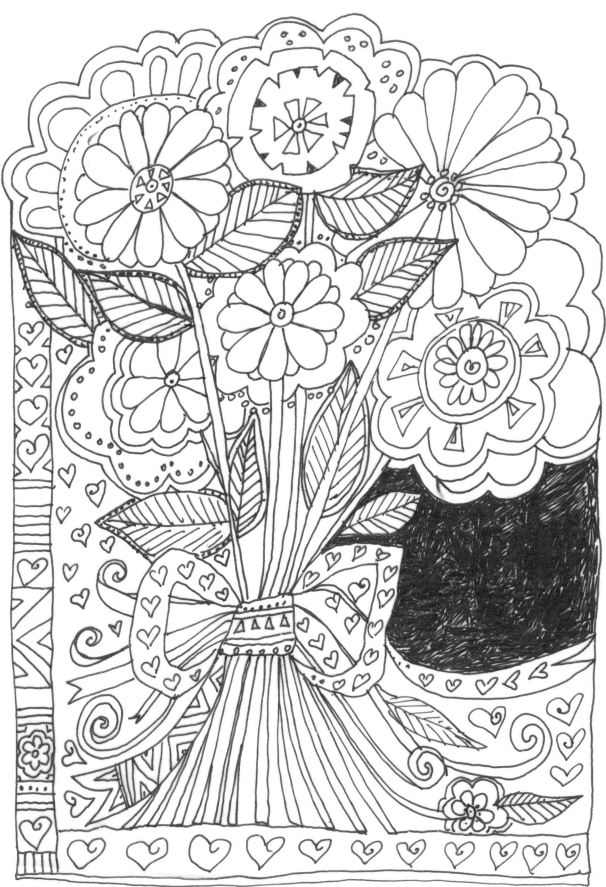

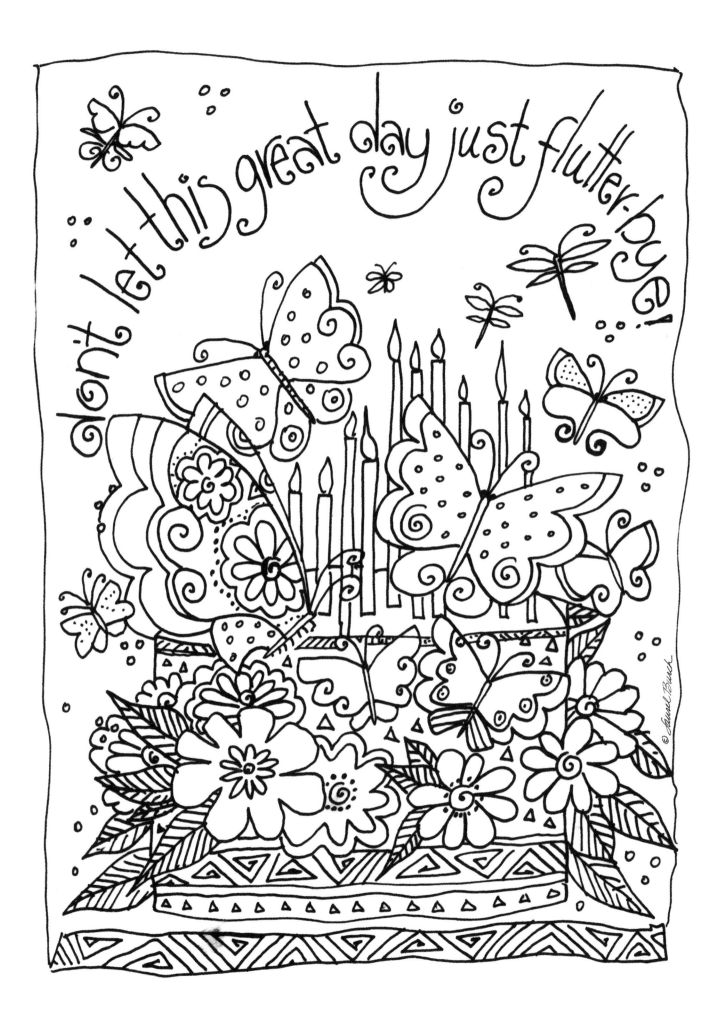

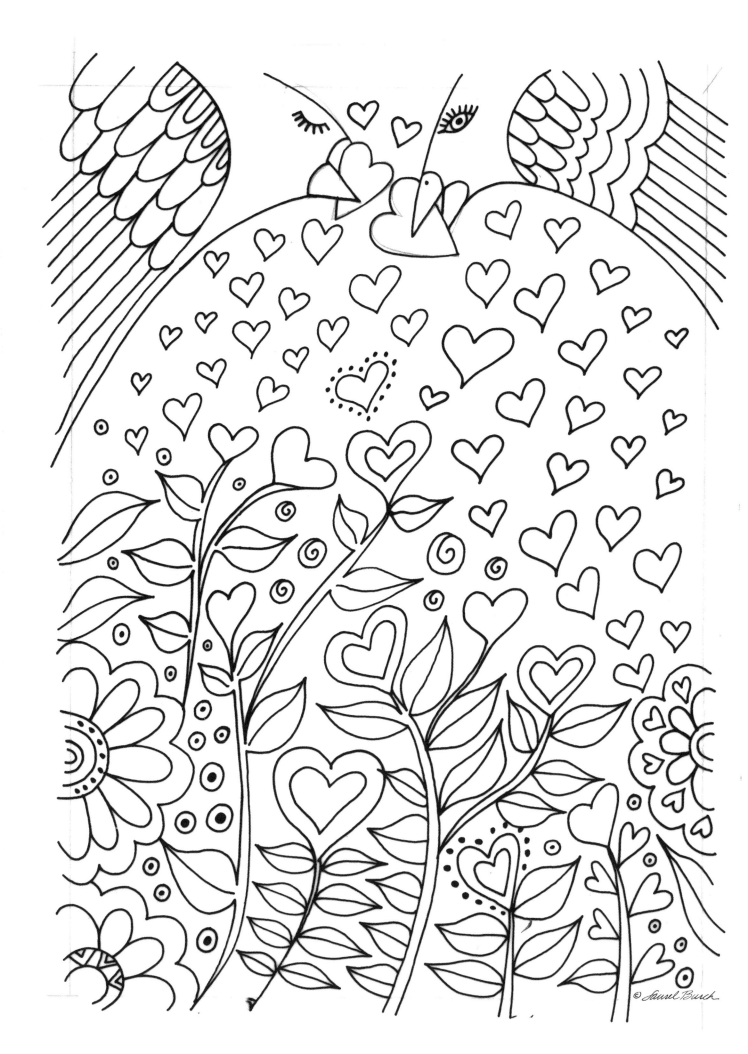

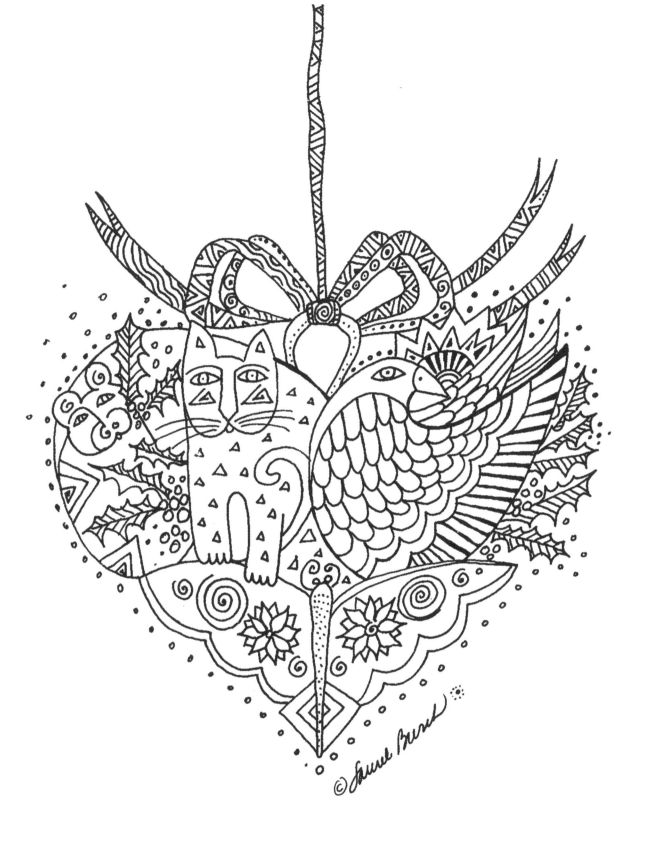

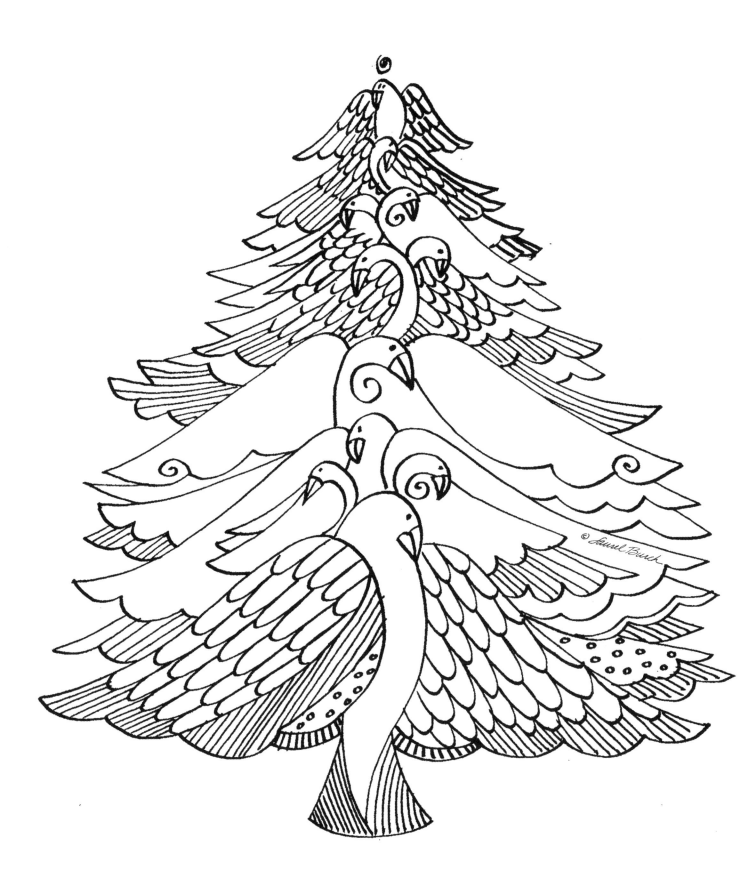

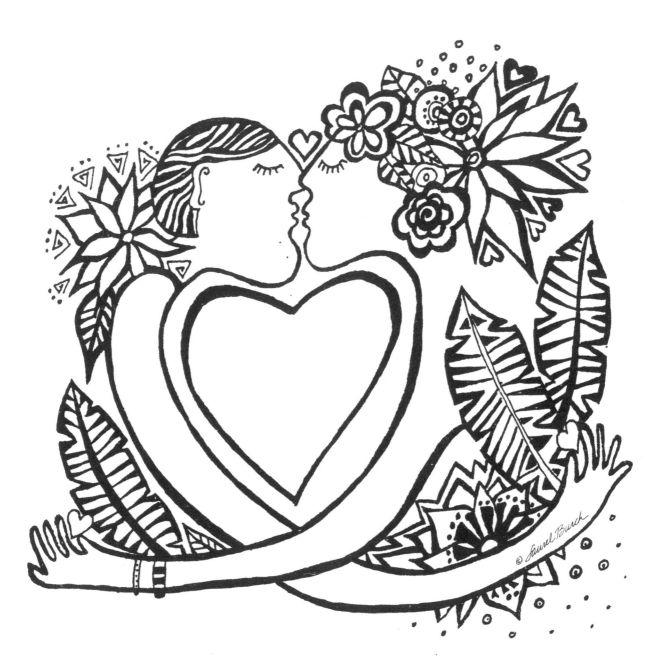

I LOVE THE BRILLIANT COLORS OF YOUR SPIRIT

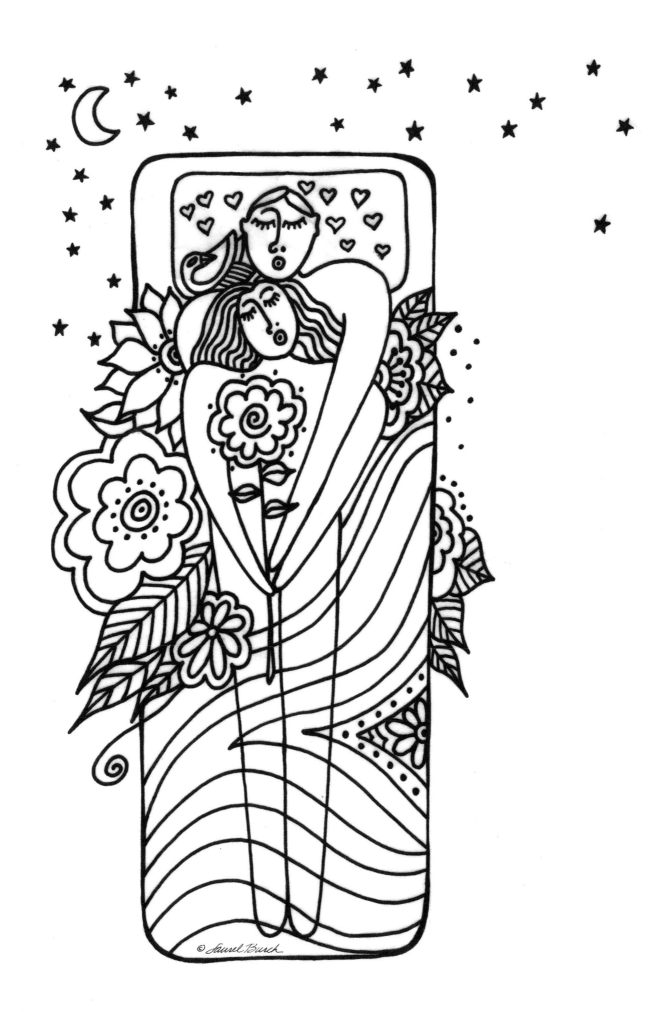

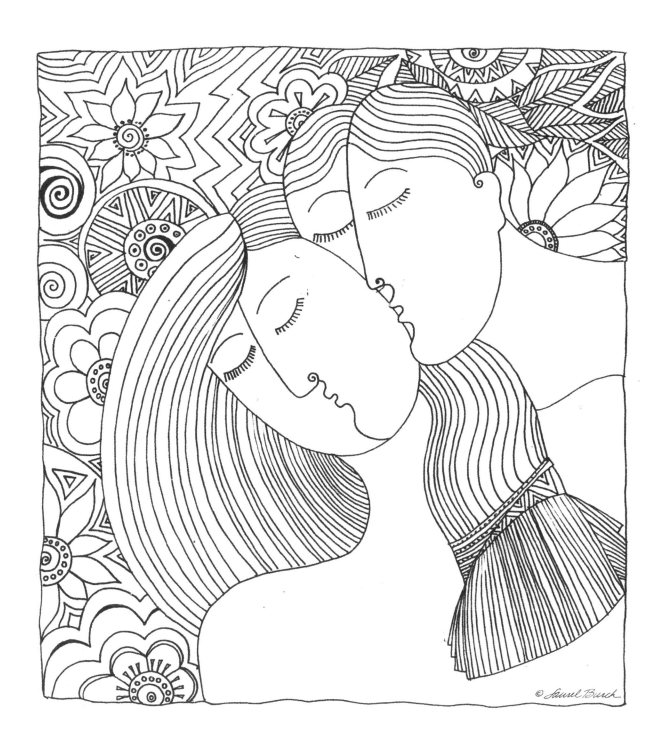

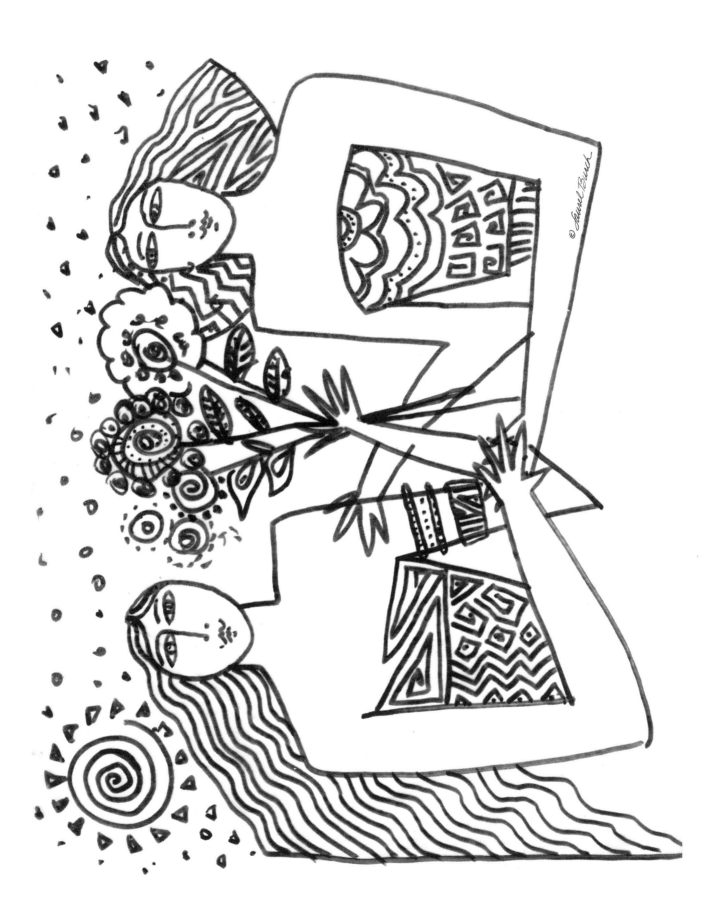

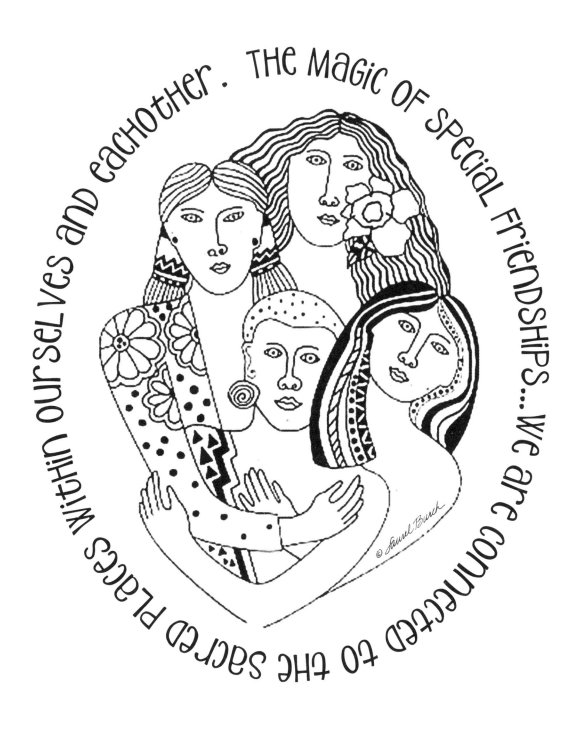

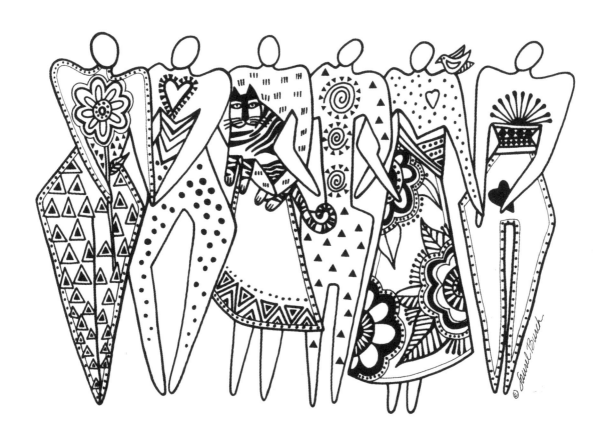
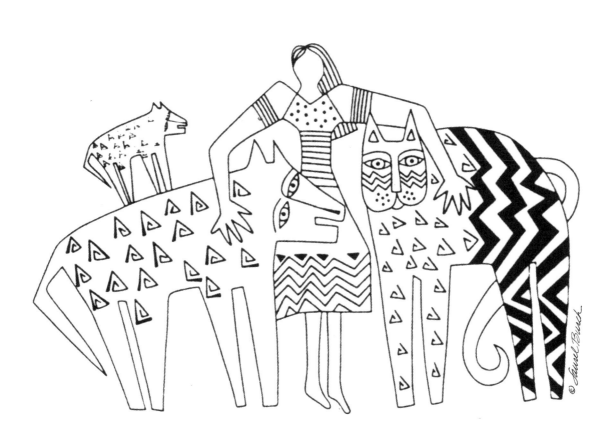

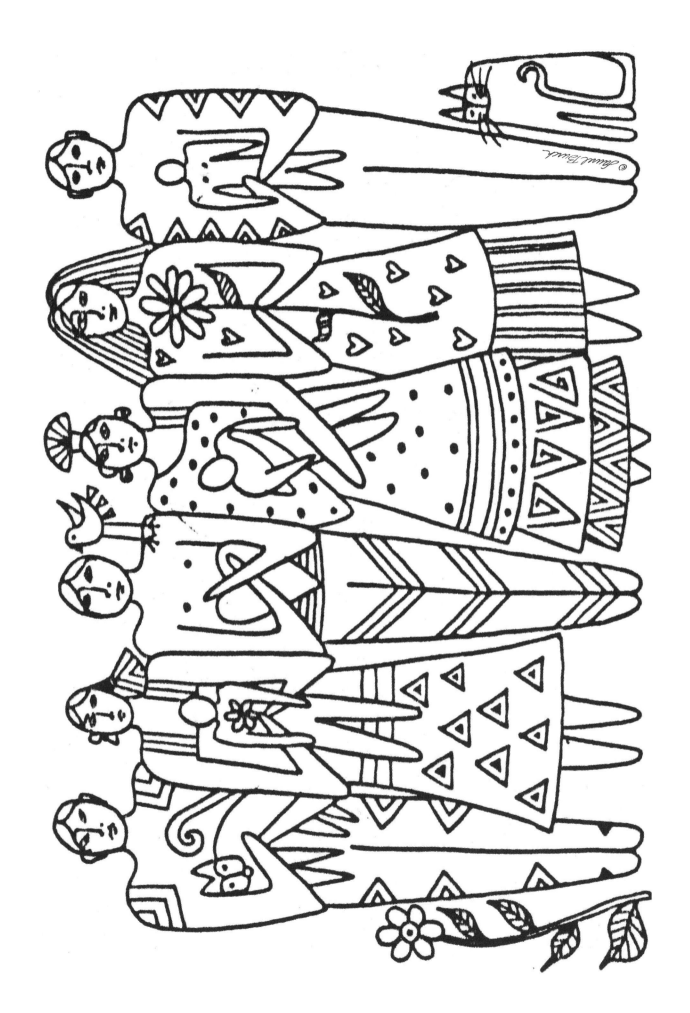

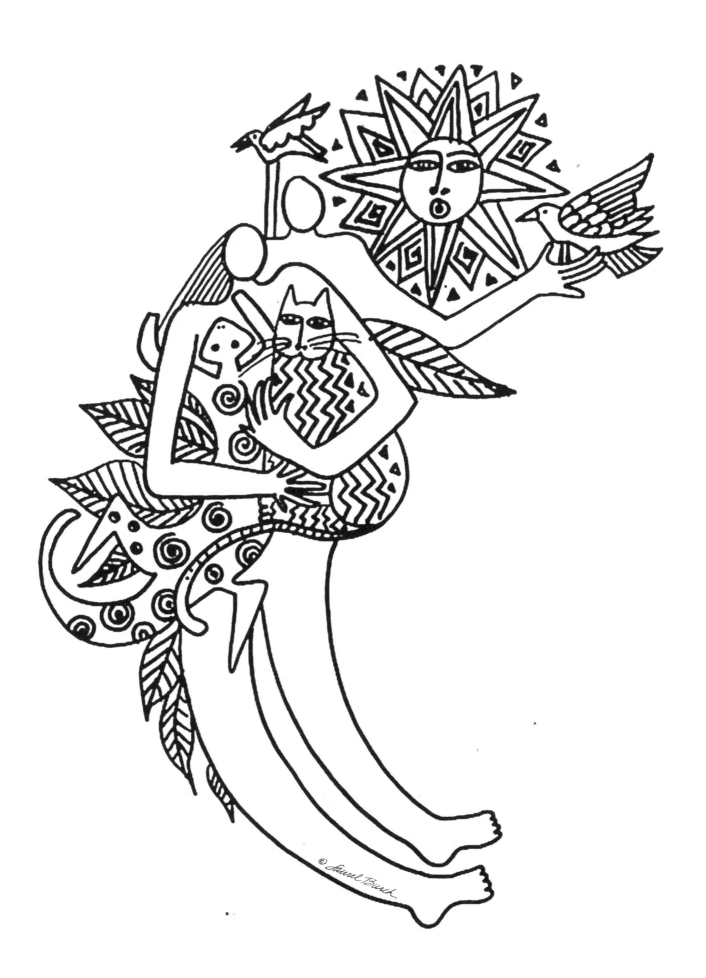

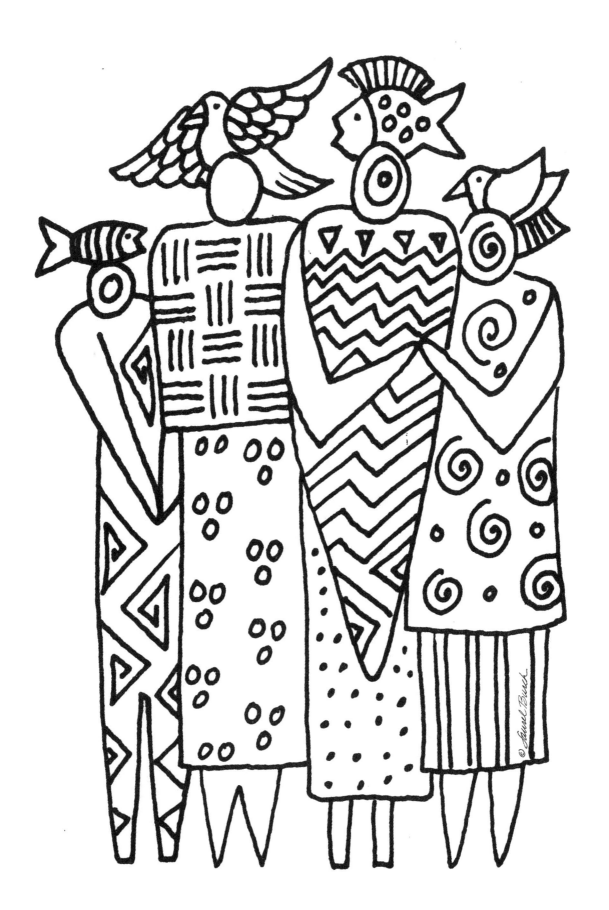

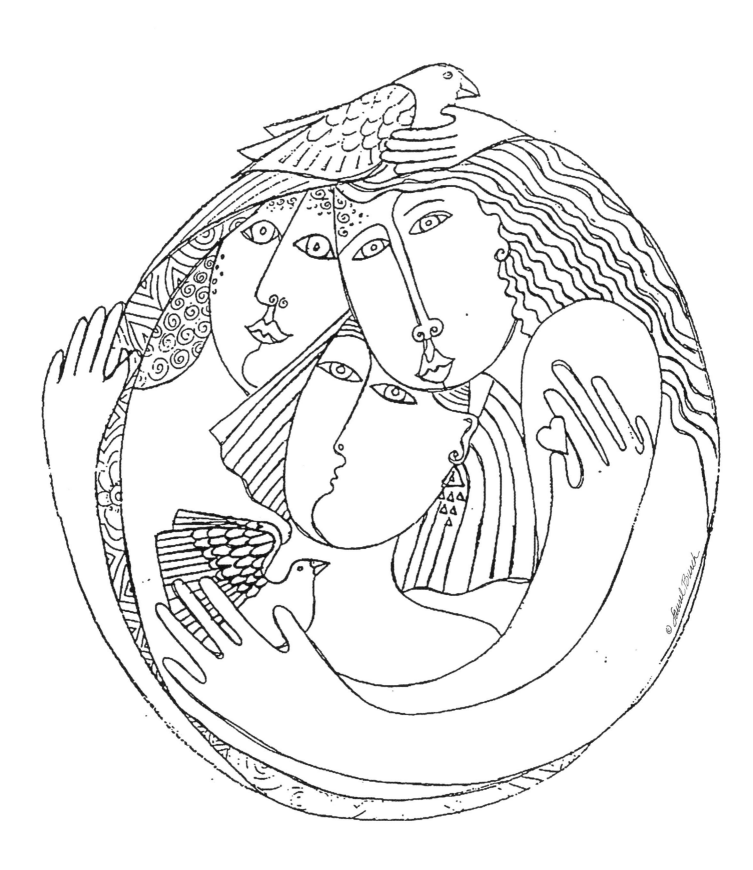

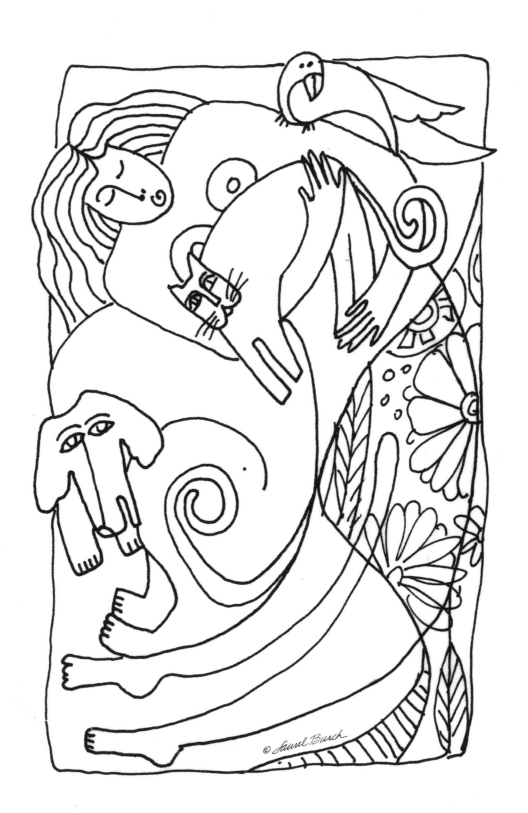